Copyright © Kingdom Bytes. All rights reserved.
No part of this publication may be reproduced, distributed,
or transmitted, in any form or by any means,
including photocopying, recording, or other electronic or
mechanical methods, without prior written permission of the
publisher, except in the case of brief quotations embodied in
critical reviews and certain noncommercial uses permitted
by copyright law.

Coloring Book

Coloring serves many purposes that are beneficial. It can be done by anyone, not just artists or creative types. It is a hobby that can be taken with you wherever you go.

7 BENEFITS OF COLORING FOR ADULTS

- Coloring is a positive activity which calms your brain and helps you to experience relief and relaxation as your mind enters a meditative state.

- Your stress and anxiety levels can be lowered while you color as it allows you to switch off your brain from other thoughts and focus only on the moment, helping to alleviate free-floating anxiety

- Coloring is very pleasurable. It provides an opportunity to experiment without worrying about failure or consequences.

- Focusing on the present helps you achieve mindfulness, which has therapeutic and health benefits.

- It It utilizes areas of the brain that enhance focus and concentration. It also helps with problem solving and organizational skills and promotes creativity

- Coloring brings us back to a simpler time which can invoke the easier and happier times of childhood

- Because coloring is a hands-on hobby, it helps you to maintain your manual dexterity, something that diminishes as people age

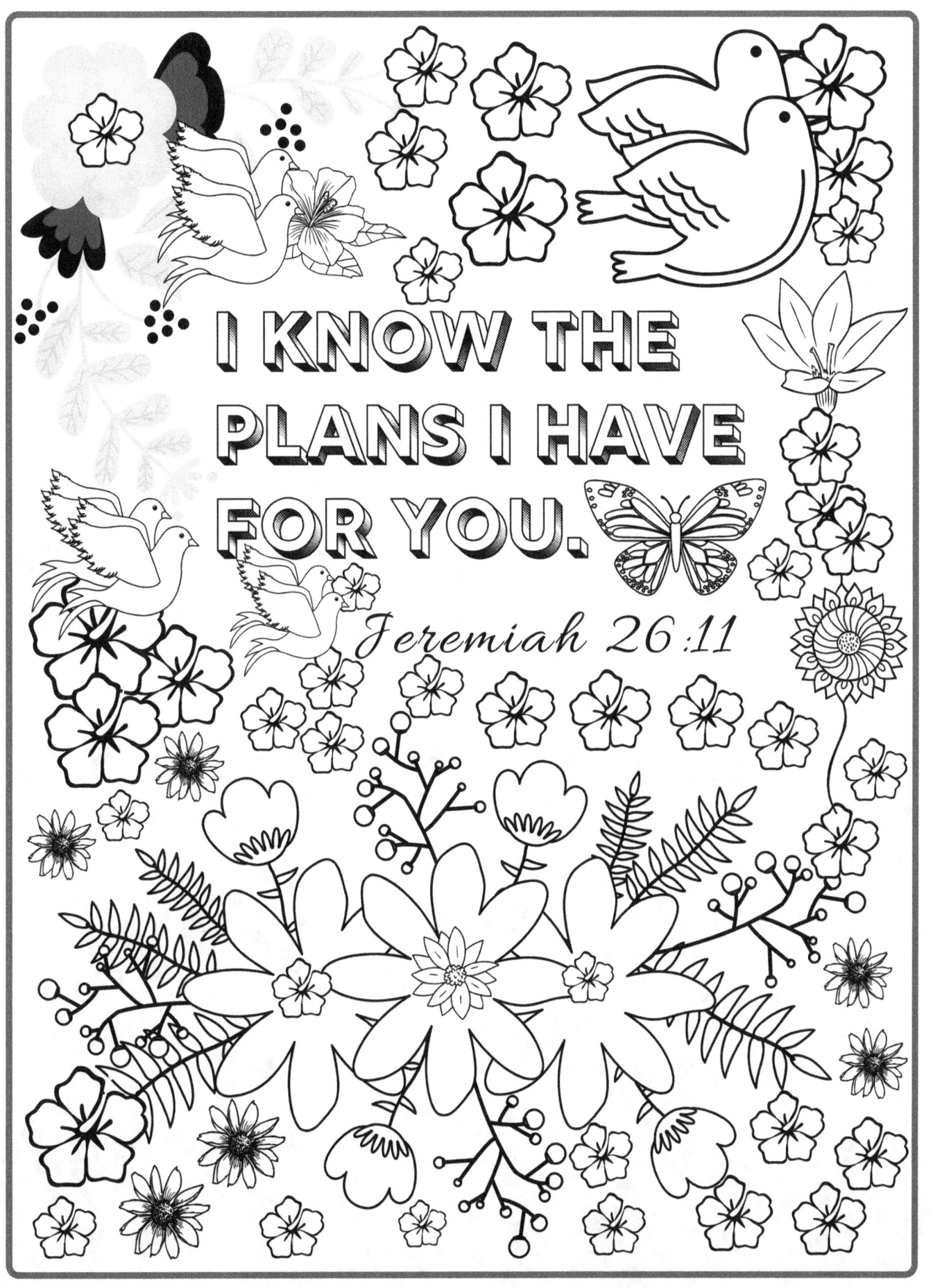

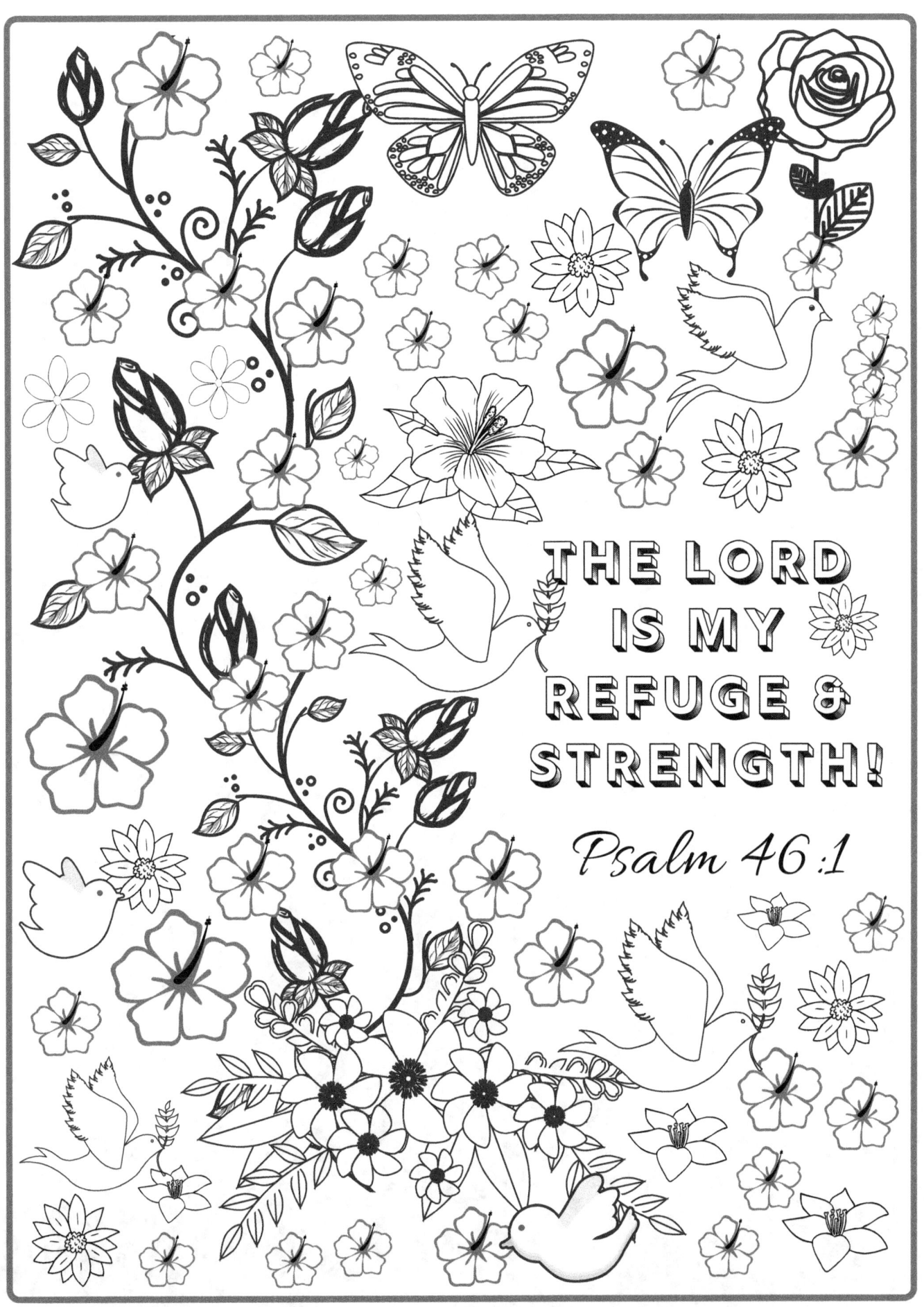

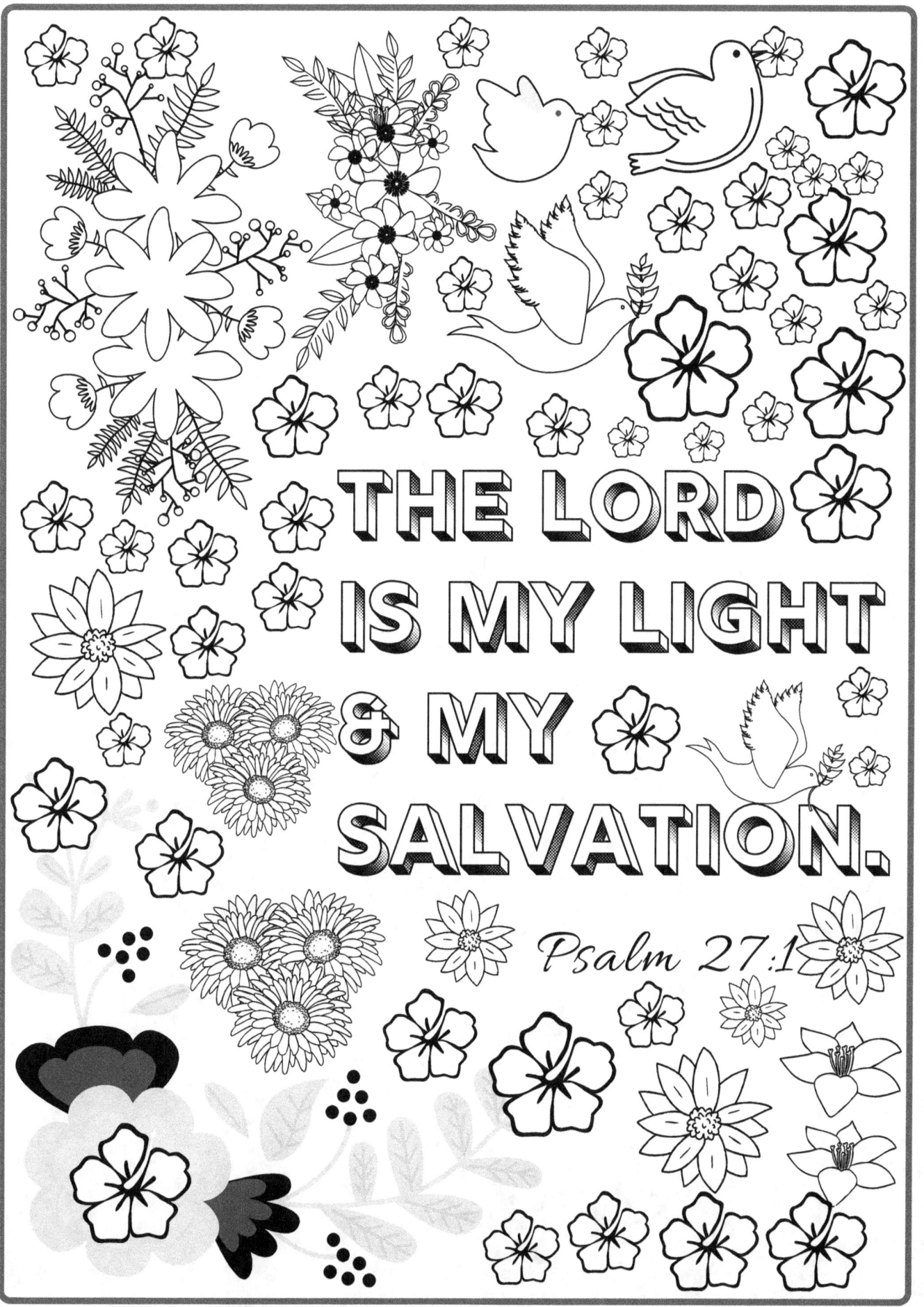

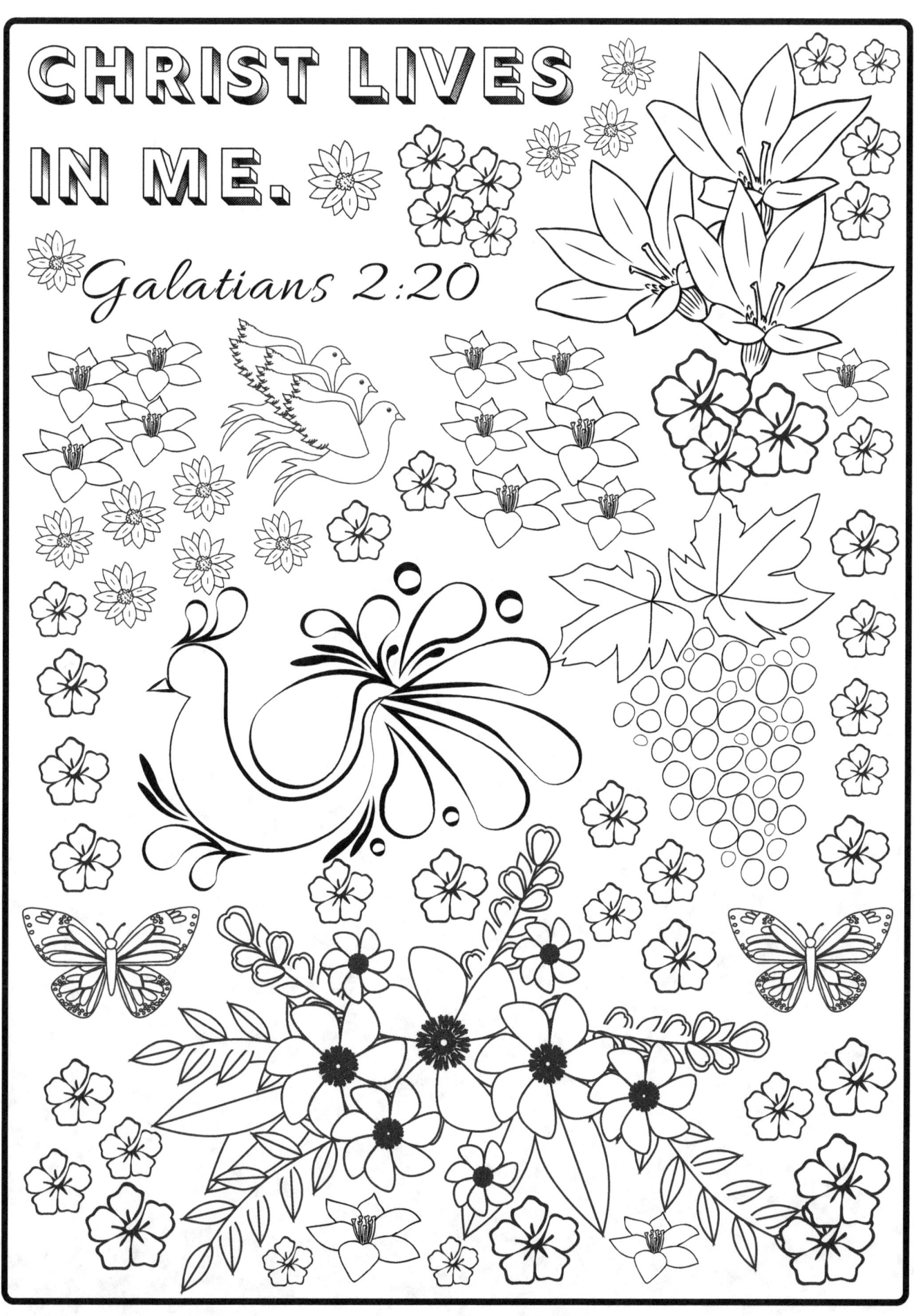

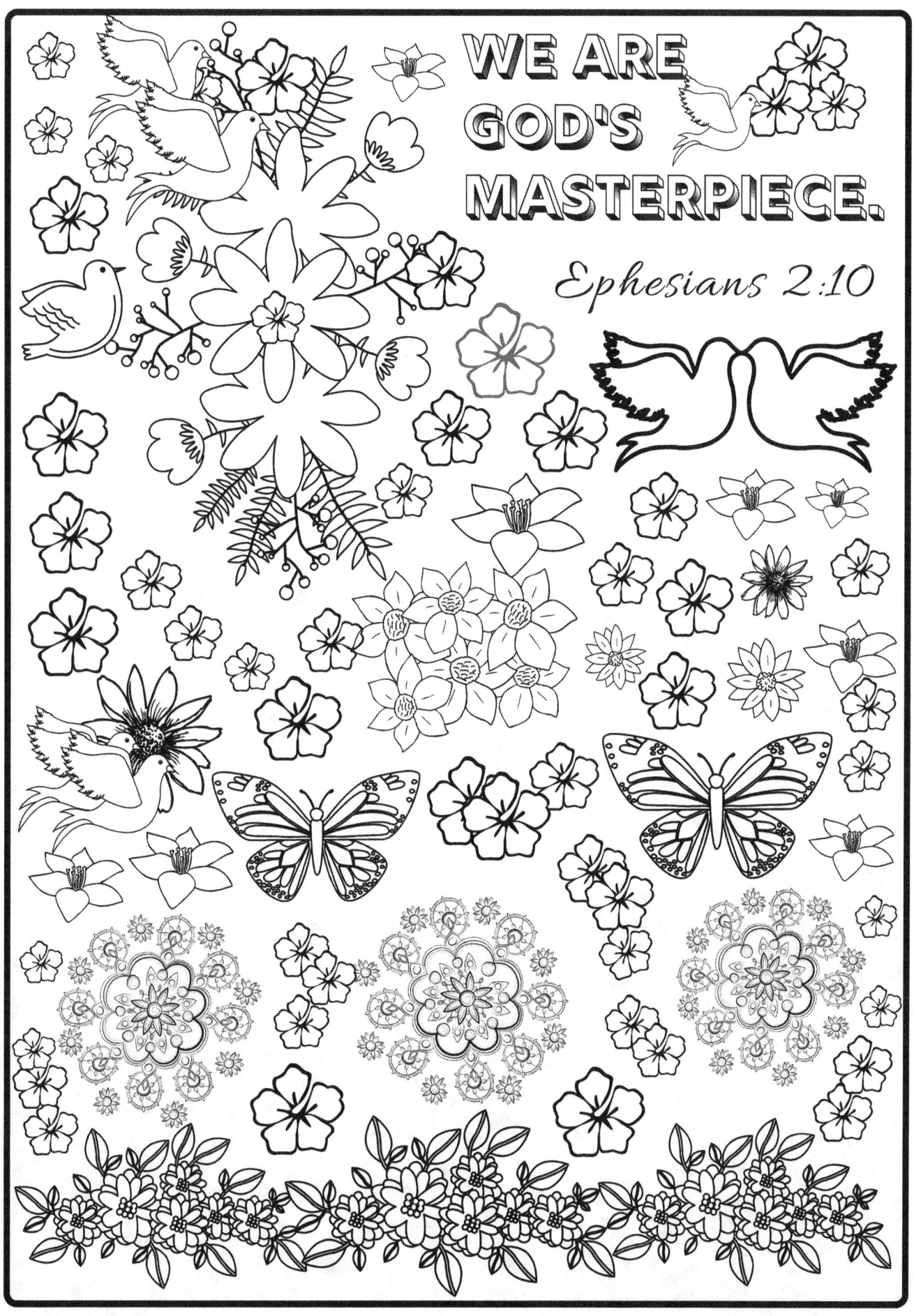

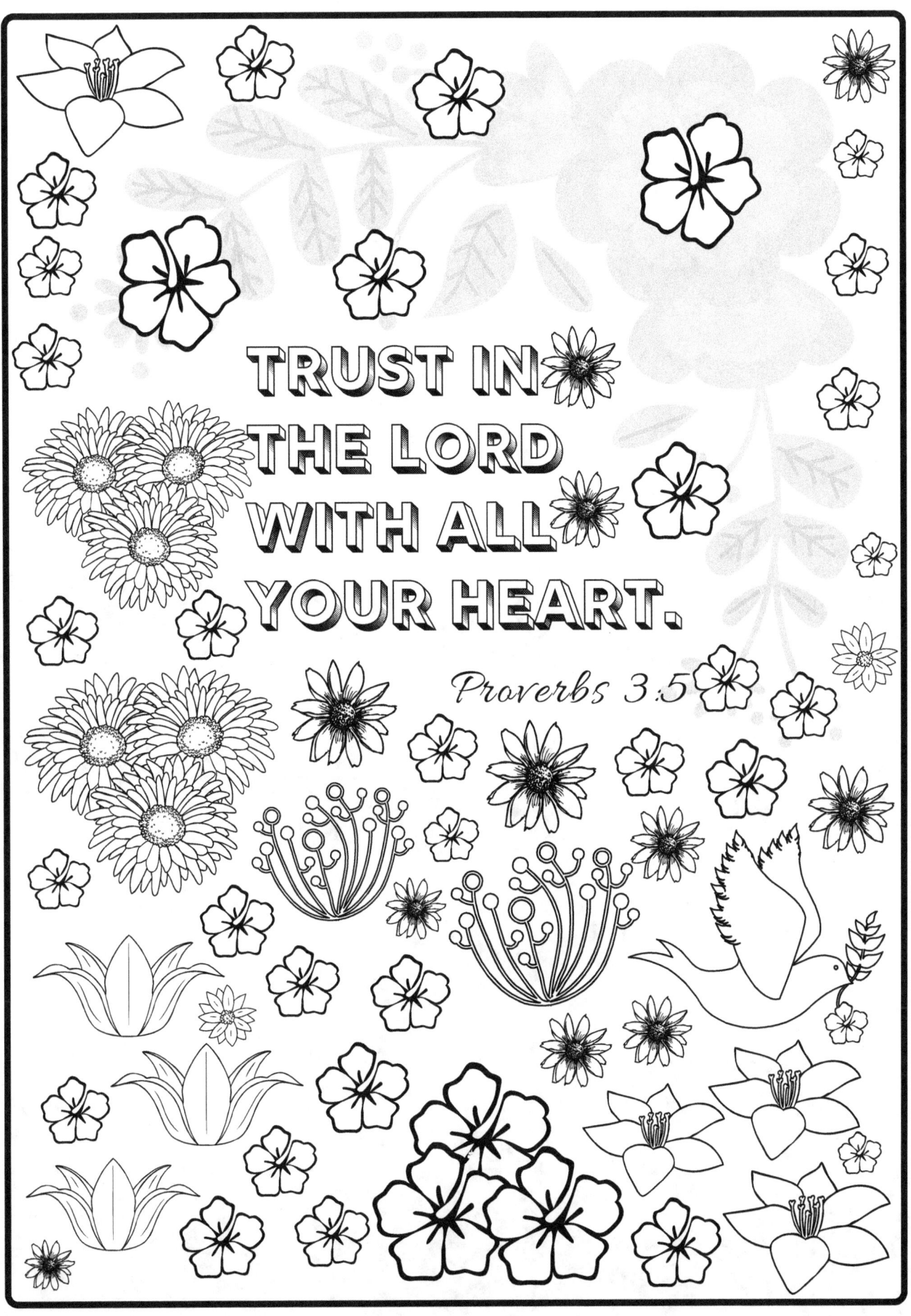

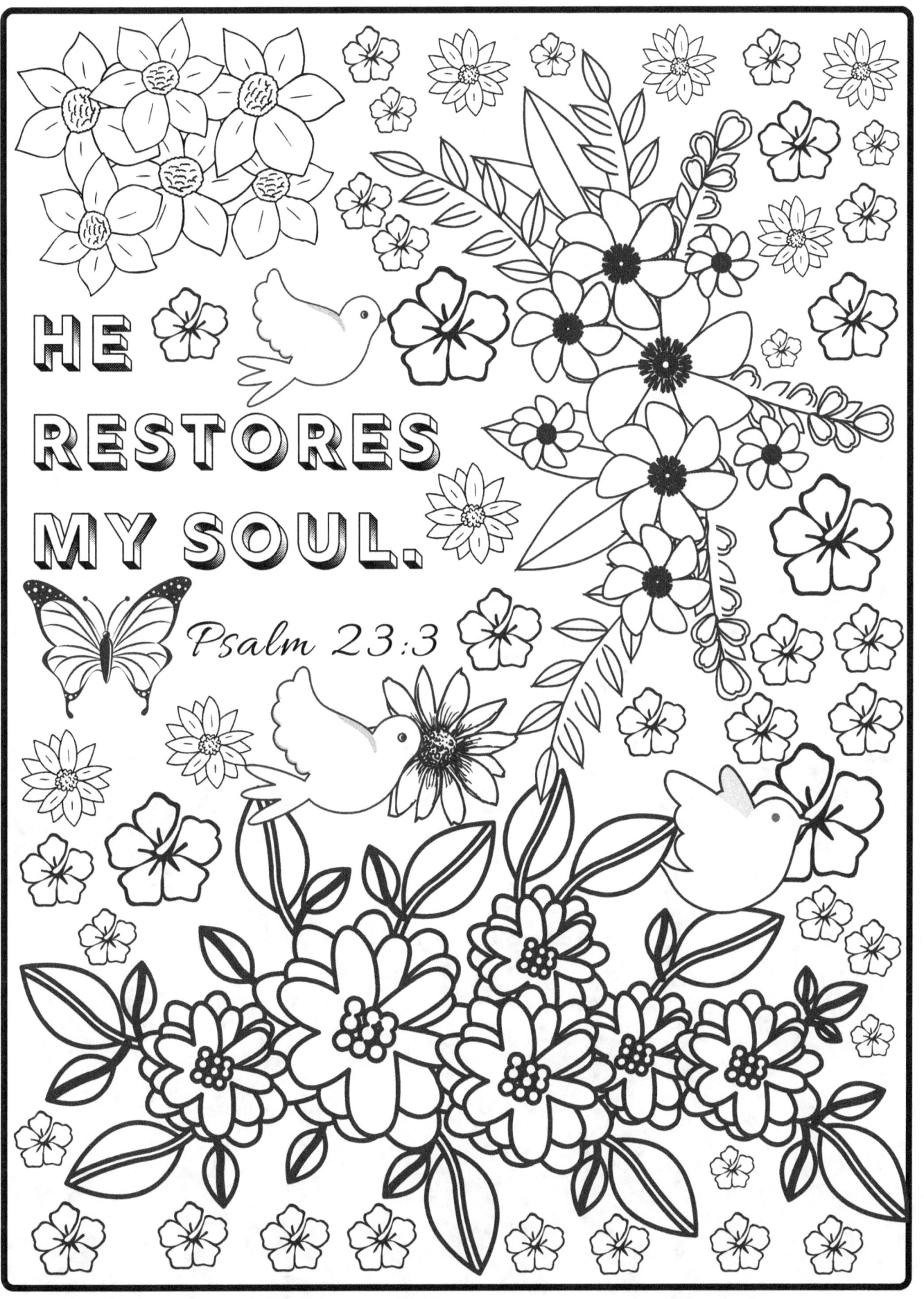

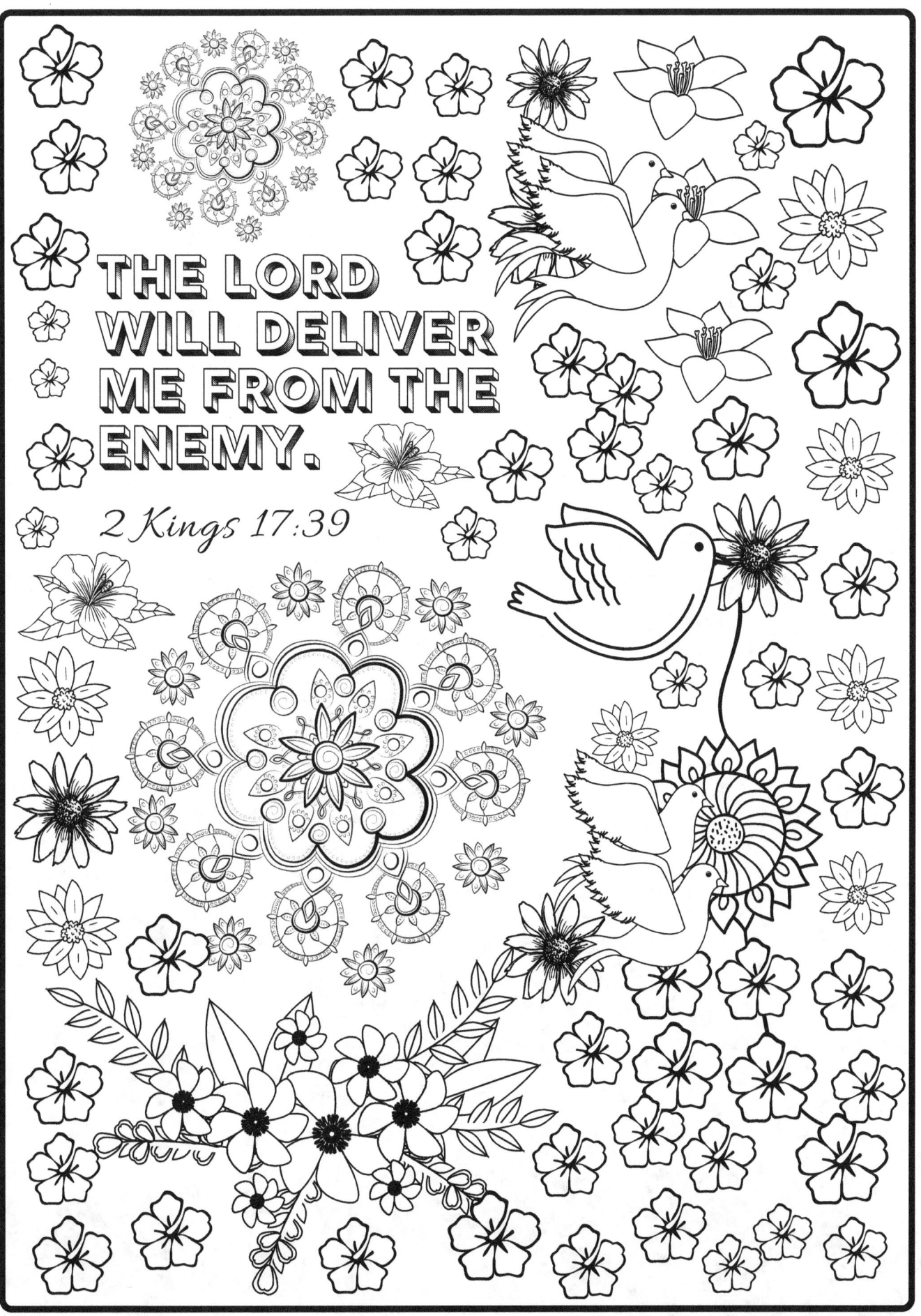

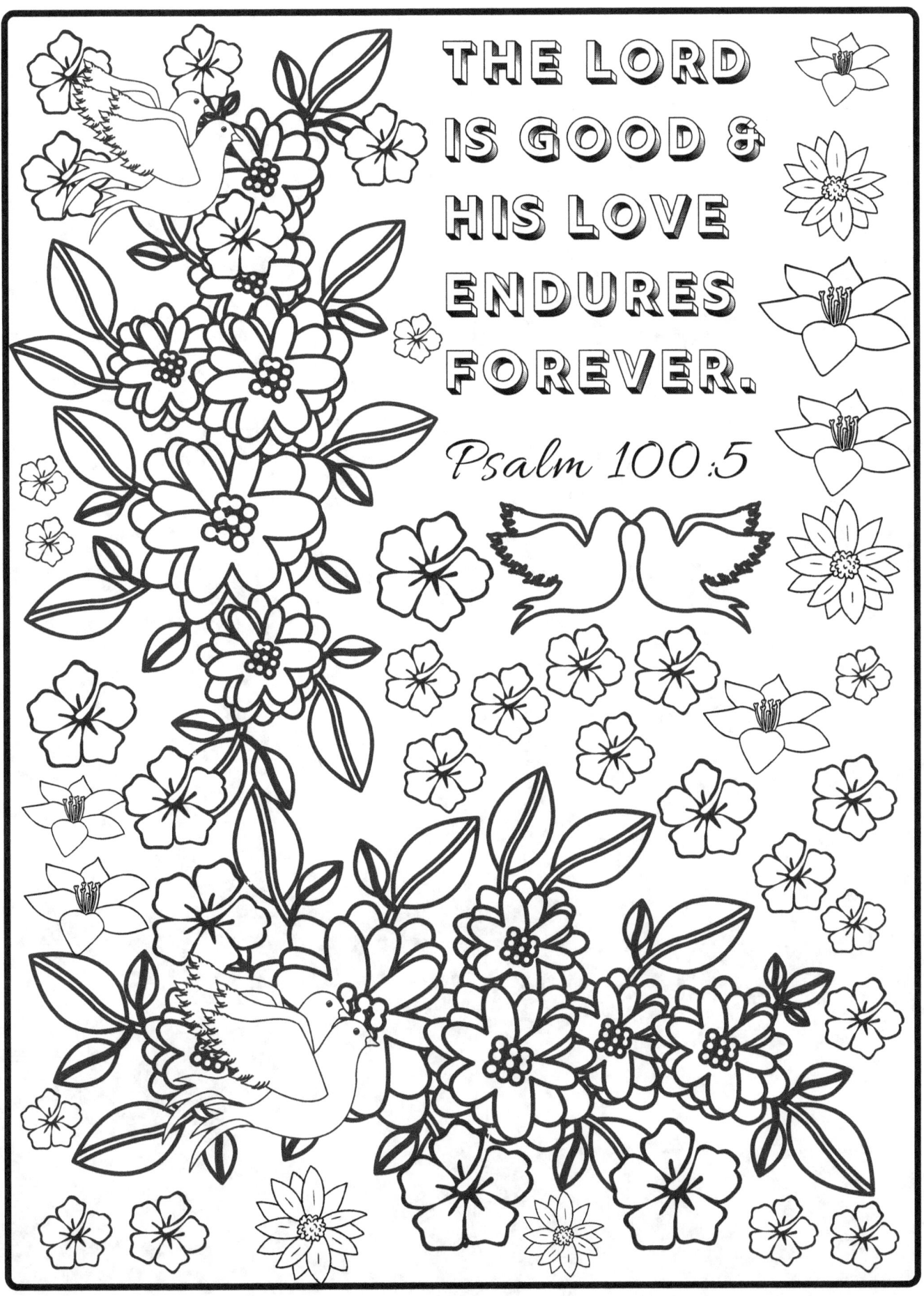

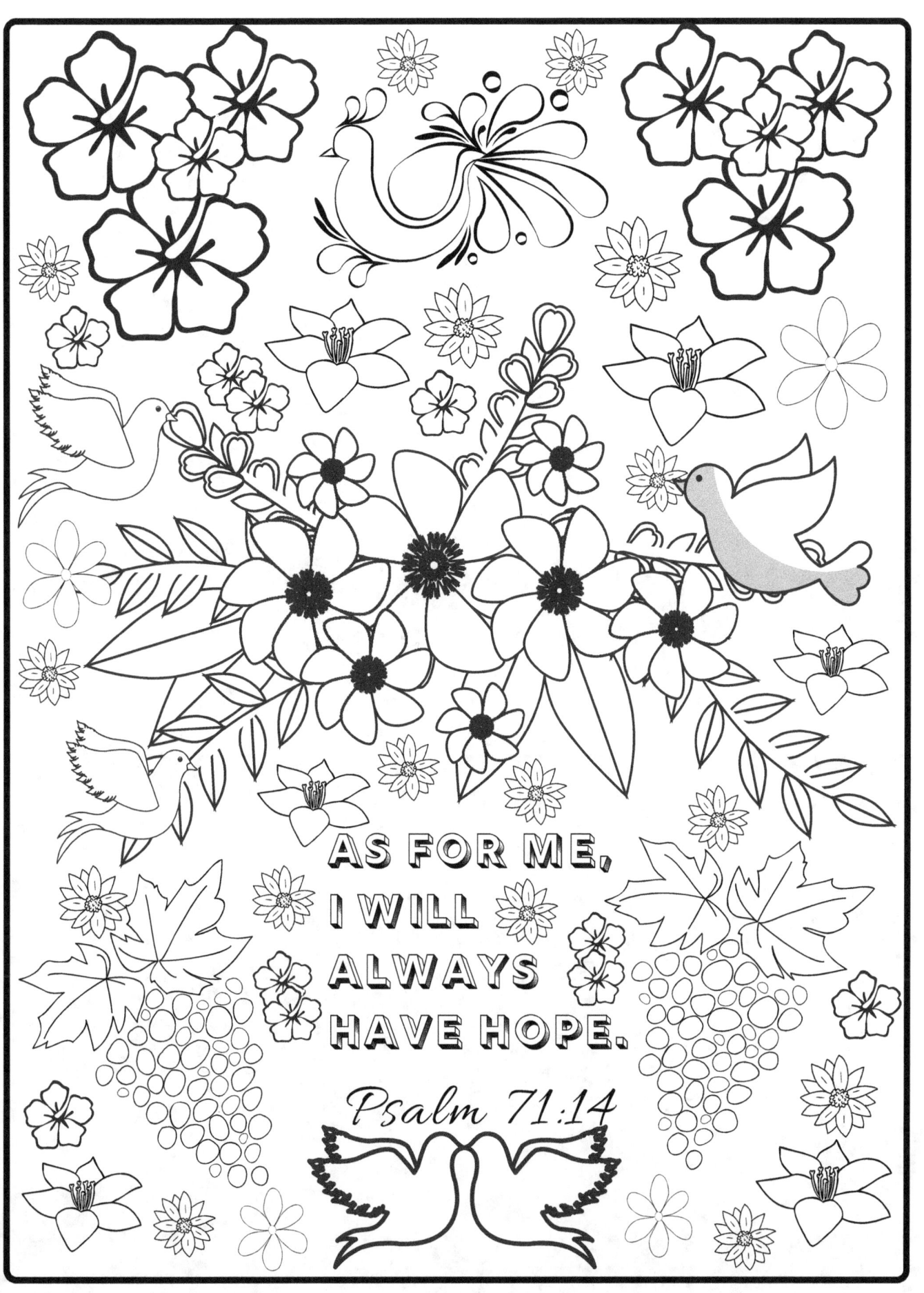

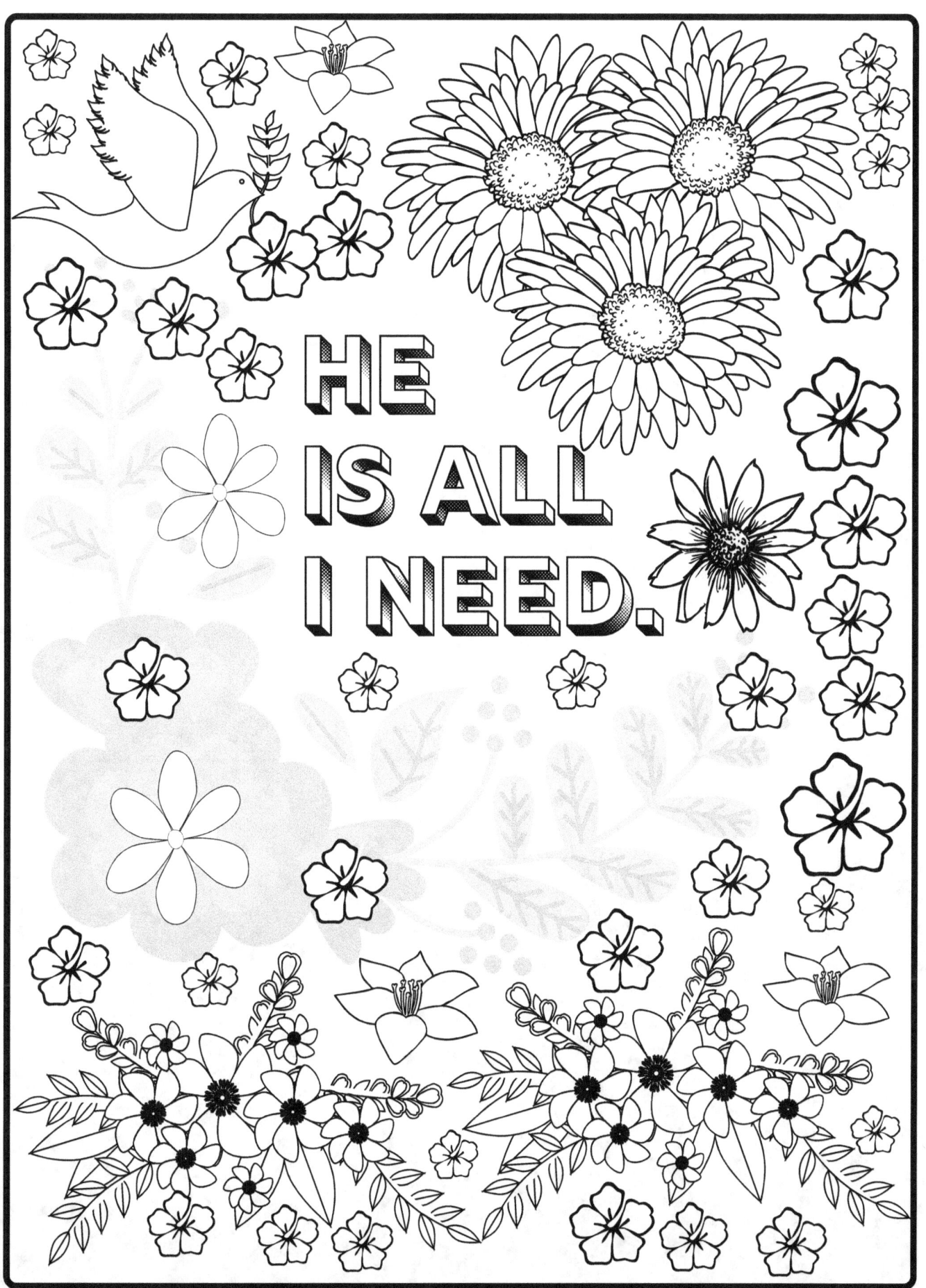

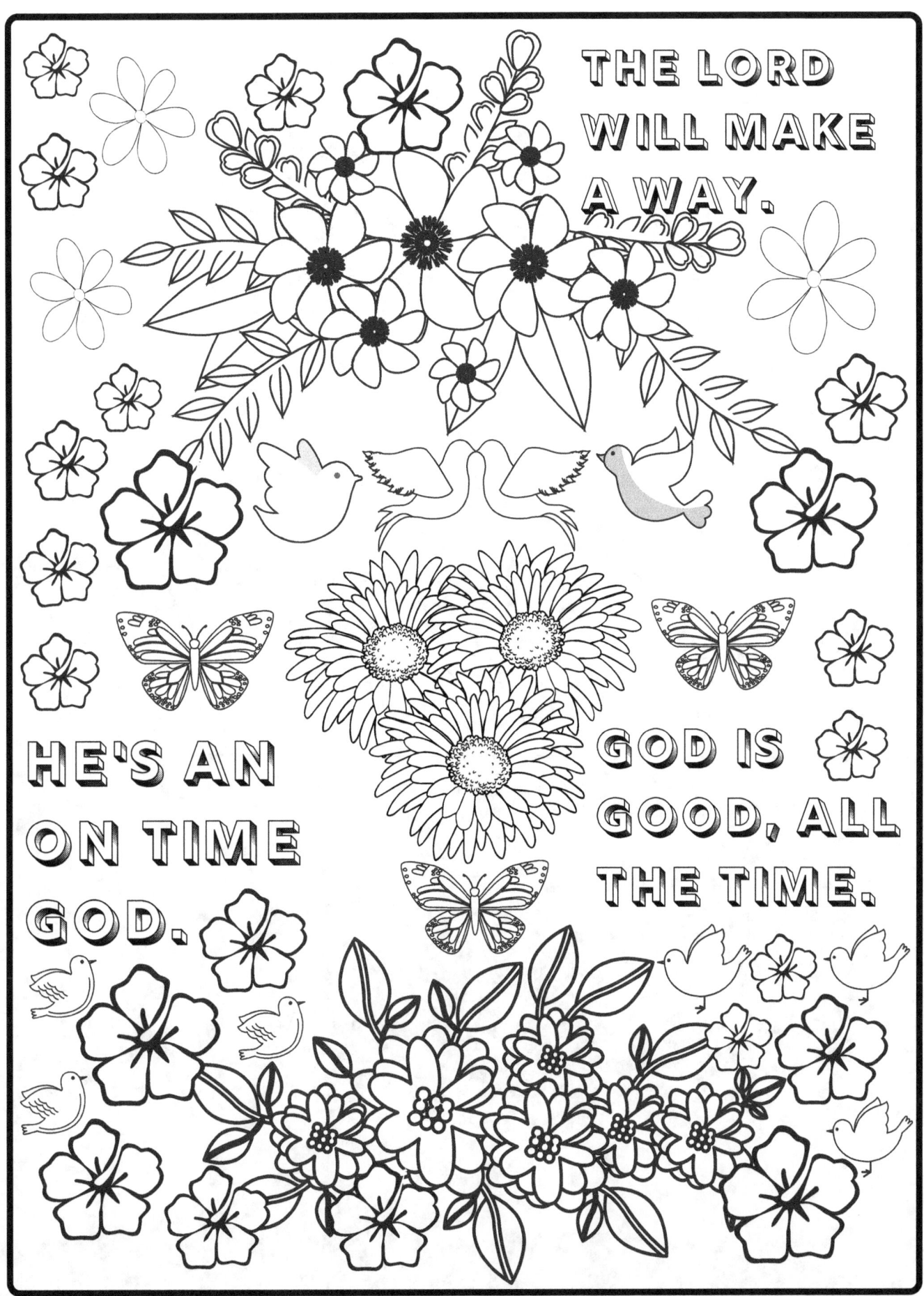

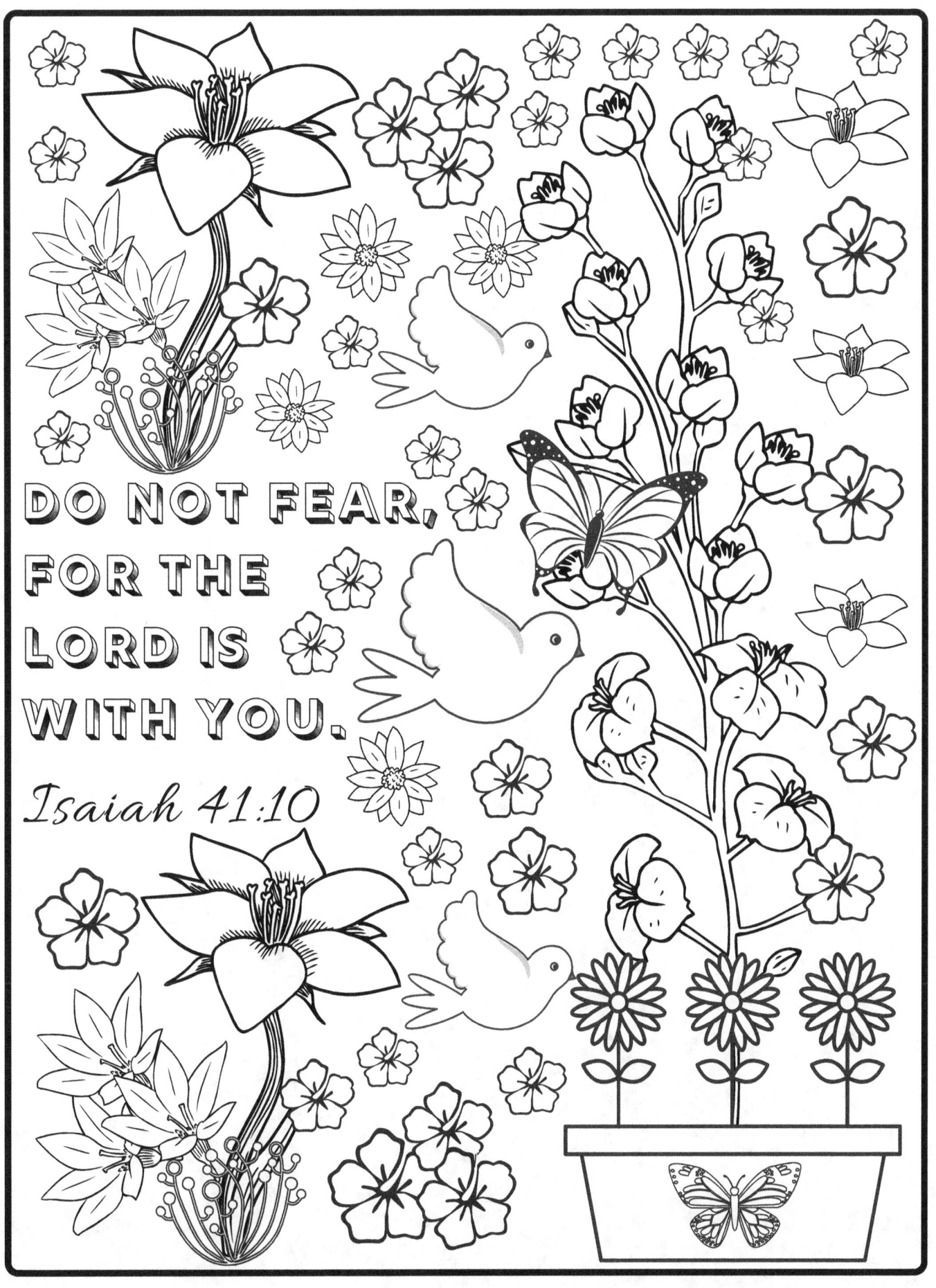

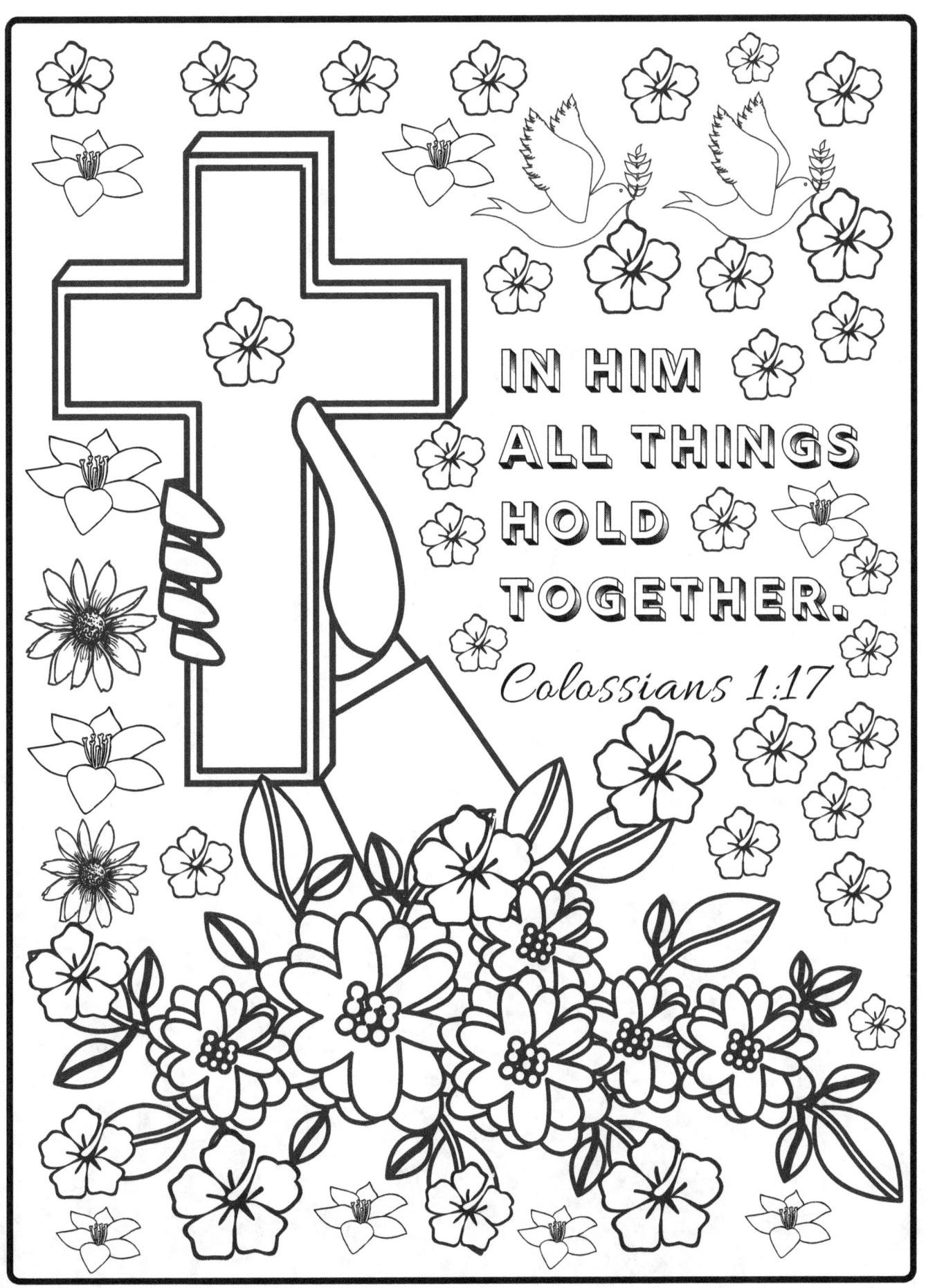

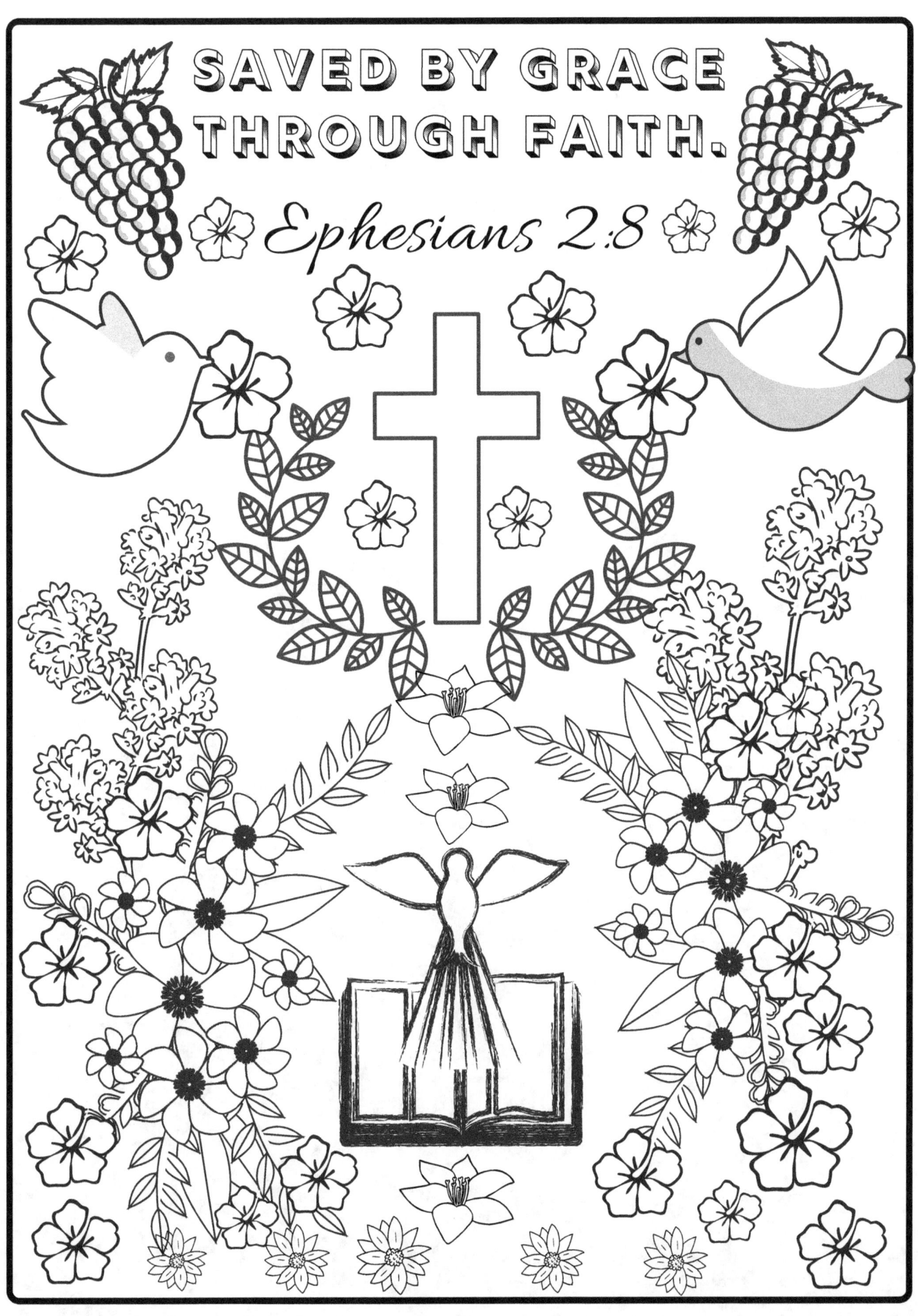

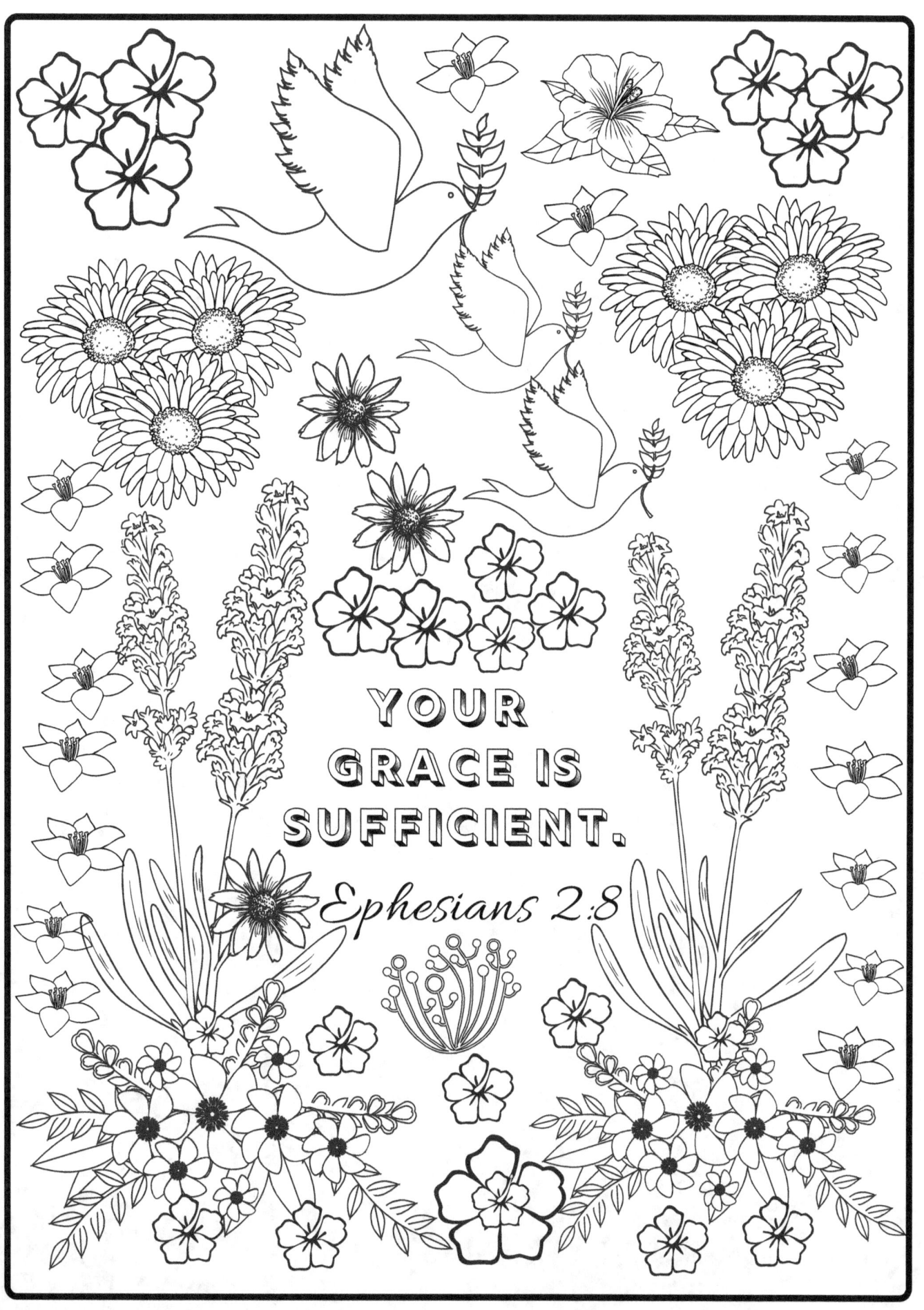

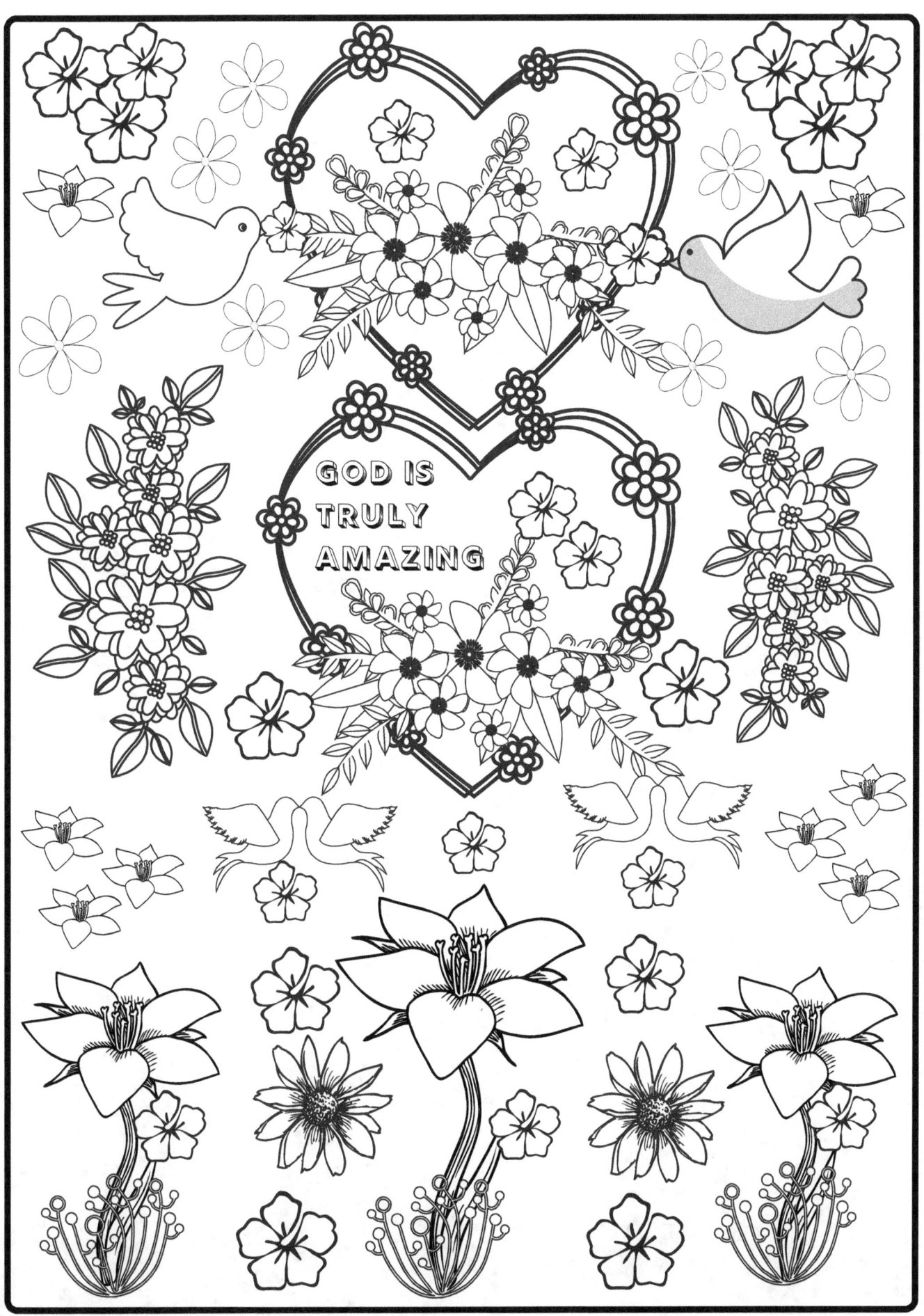

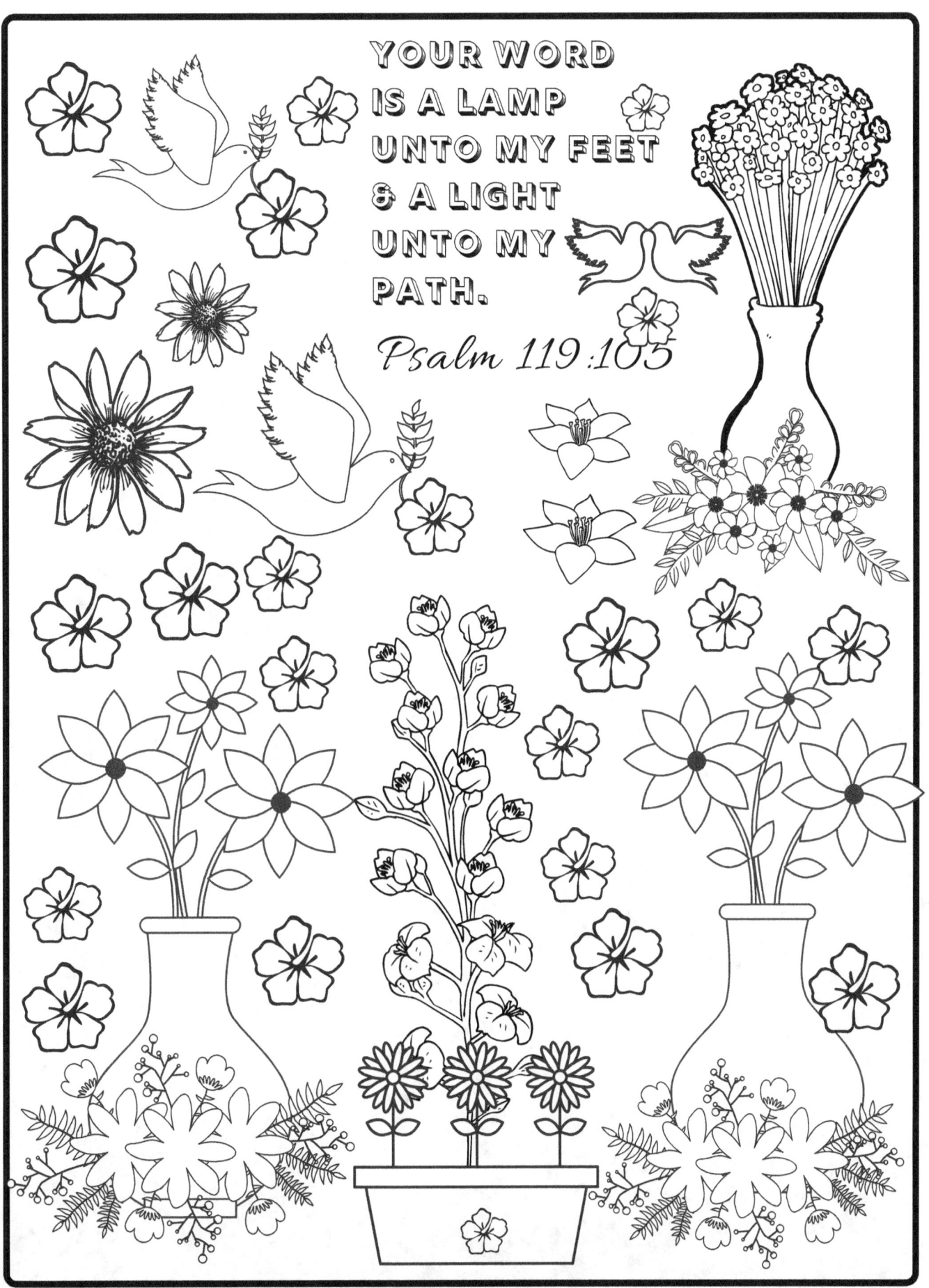

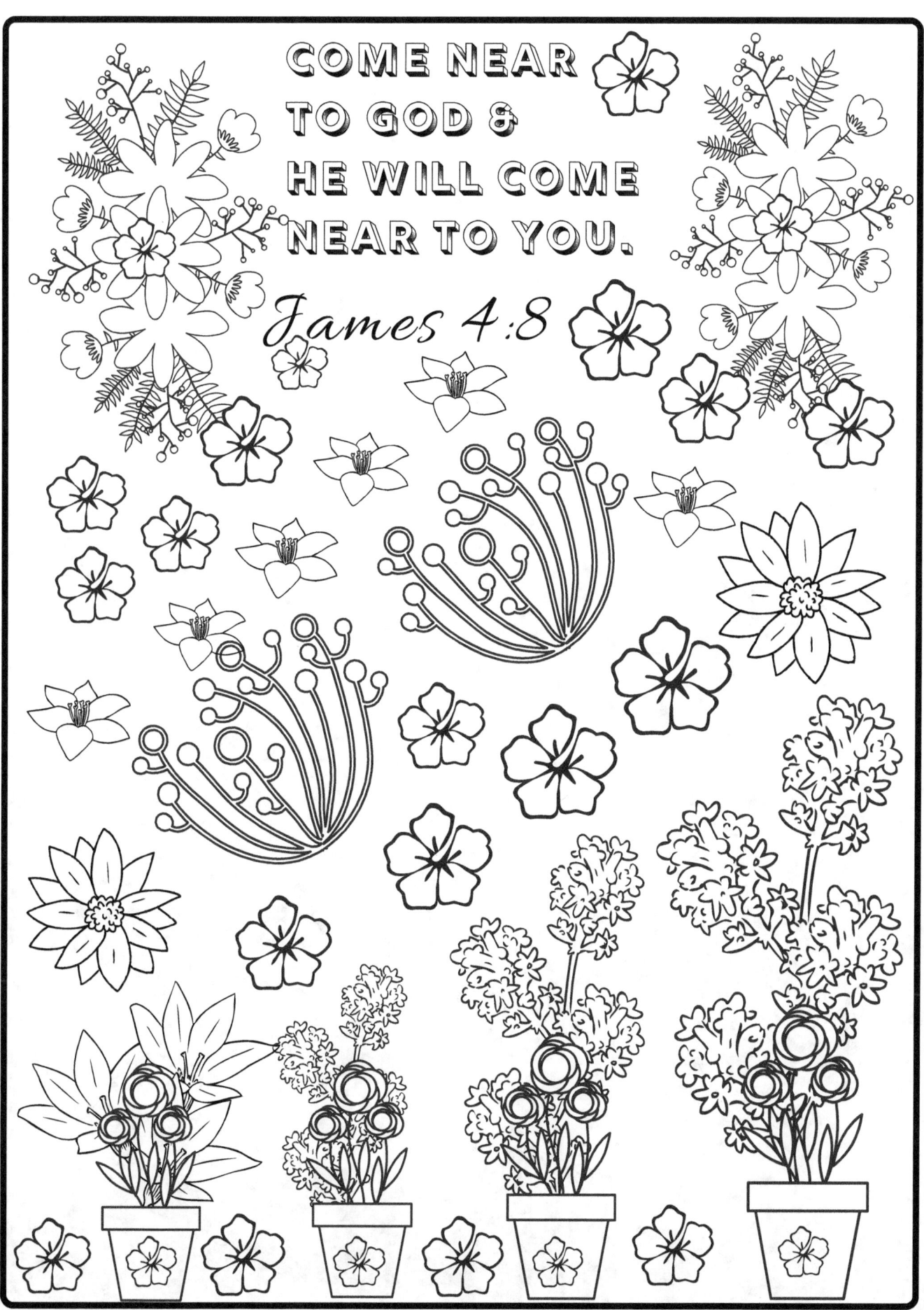

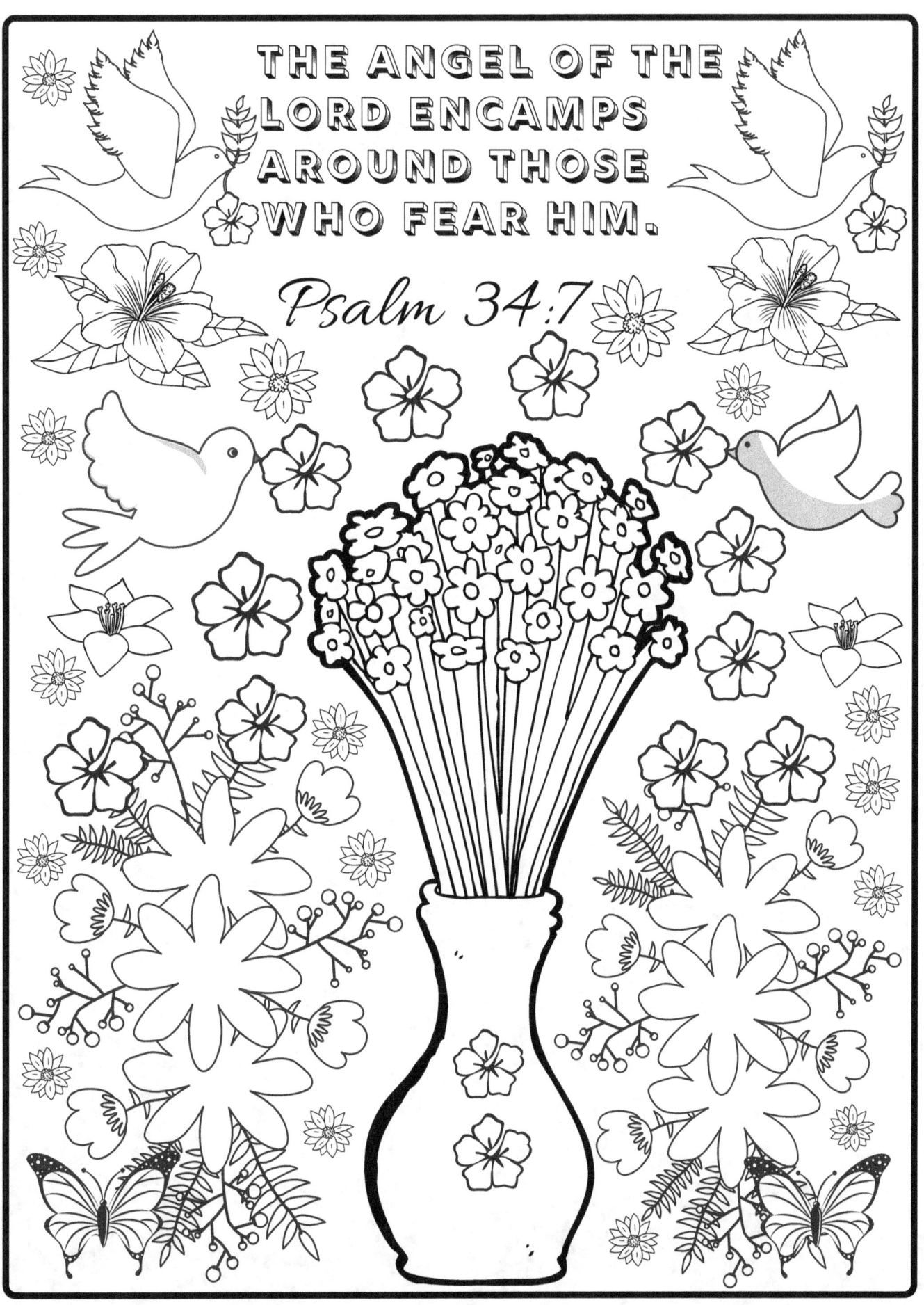

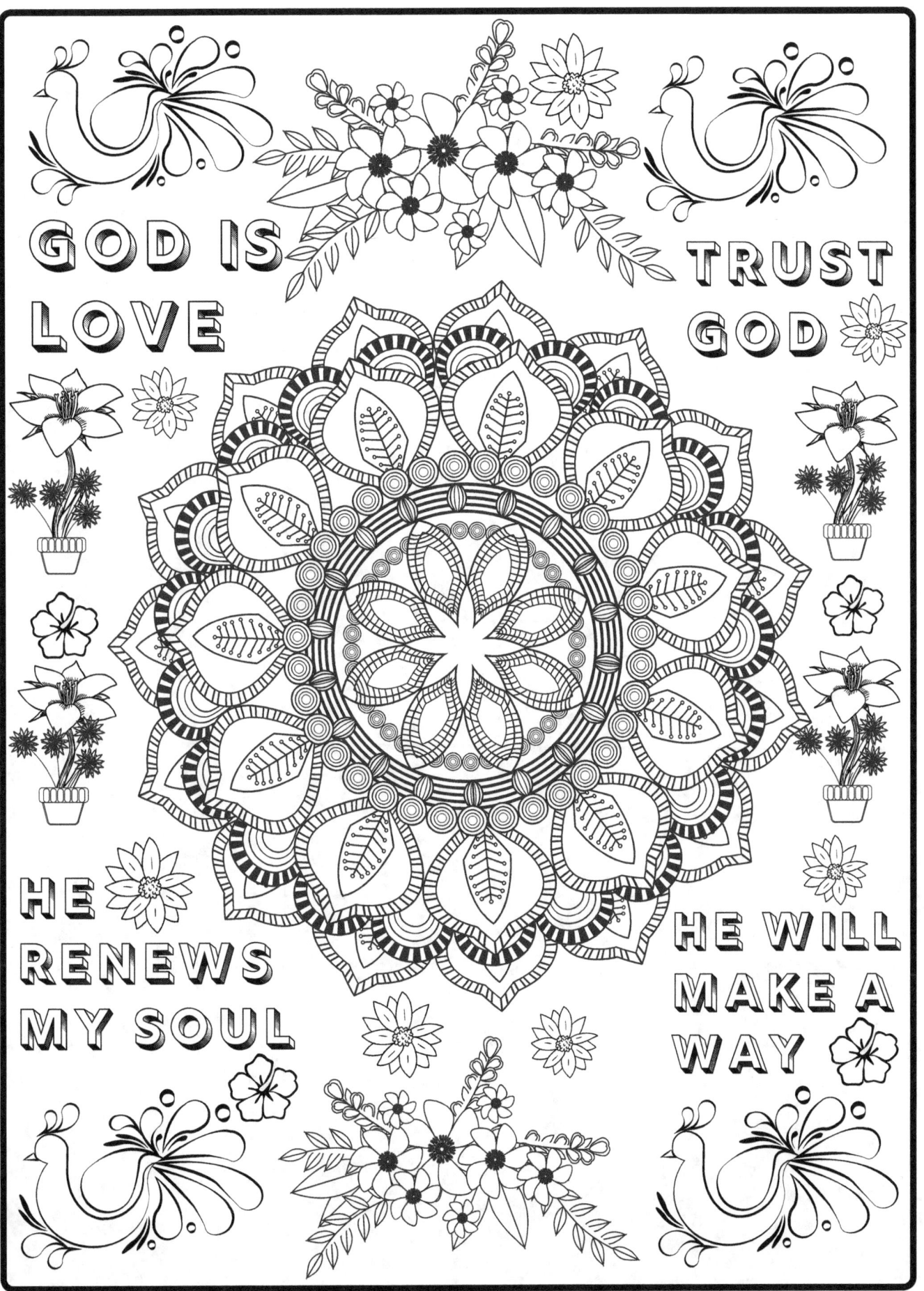

LOOK AT THE BIRDS OF THE AIR, FOR THEY NEITHER SOW NOR REAP NOR GATHER INTO BARNS; YET YOUR HEAVENLY FATHER FEEDS THEM. *Matthew 6:26*

Ideas For Selfcare

- Take a mental health day, and do not feel an ounce of guilt about it
- Unplug for an hour. Switch everything to airplane mode and free yourself from the constant bings of social media and email.
- Burn a candle or diffuse some oils that have scents that bring you joy
- Walk around the grocery store without a list; Buy some stuff just for fun
- Start a compliments file. Document the great things people say about you to read later
- Sing at the top of your lungs, in the car, with the windows down
- Go to the library or bookstore; Sit in a comfy chair and read
- Go cloud-watching. Lie on your back, relax, and watch the clouds float by
- Do something crafty: knitting, sewing, painting.....
- Take a bubble bath with candles and calming music
- Sit in a coffee shop and sip on a luxurious drink
- Sit on the front porch; Just sit and do nothing
- Pick or buy a bouquet of fresh flowers
- Go for a drive - no destination required
- Have a dance party to your favorite music
- Wrap yourself in a soft, warm blanket
- Give yourself a pedicure or a manicure
- Read a book or magazine for an hour
- Take a leisurely walk without a goal
- Put on a homemade face mask
- Watch funny YouTube videos
- Color in your coloring book
- Write in your Journal
- Try out a new hobby
- Look at the stars
- Sit in the sun
- Meditate
- Take a nap